COLORING
ADORABLE TOWN

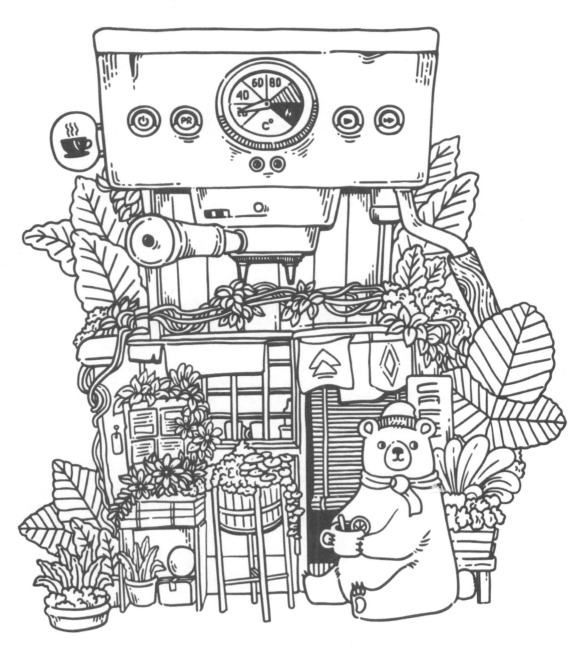

ILLUSTRATED BY **LAINIE DAO**

THIS BOOK BELONG TO

..

ILLUSTRATED BY **LAINIE DAO**

TIPS & TRICK

P1. THE BASIC

1.PREPARE GOOD COLOR PENCILS
When purchasing colored pencils, the first feature you need to look for besides the price is the quality. The result of your drawing heavily relies on the quality of the pencils you use.

2. KEEP THE PENCILS SHARPENED
It is important to always keep a sharpener beside the colored pencils.
You may be wondering why we're stressing on keeping the pencils sharp and what difference does it make.

3. CHOOSE YOUR COLORS
On the way to becoming a great artist, it is important to understand and learn about different colors.

4. THE RIGHT SURFACE
It's no surprise when we catch ourselves overlooking the paper surface sometimes, especially when we're just very excited to get started already. But if we pause for a moment to think about the outcome, we might want to reconsider the rush.

P2: THE TECHNIQUES

Sometimes techniques can be very complicated but the following are both simple and easy to follow.

1.PRESSURE
The pressure you apply on the colored pencil decides how your painting will look like in the end. And the problem usually comes up while layering — not all layers need the same amount of pressure to be used.

2. LAYERING
There are times when you'll notice that a single color does not give full coverage to the area in the artwork because it can either be too thin or too dull. In such cases, applying more layers is necessary.

3. STROKES DIRECTION
The direction of the strokes will decide how the texture of the drawing will be. If they go in every direction possible, that will leave the piece look uneven and messy.

4. MIX THE COLORS
The benefit we get from mixing colors is that they appear to be more natural.
Mixing colors is a technique which produces exceptional results, yet, working with it does not come very easy.

5. CREATE YOUR OWN SHADE OF BLACK
Similar to the previous point of creating your own shades, we shall also focus on how you can produce a unique shade of black which can meet unique preferences as well.
Finding a natural black or white can be pretty hard in the world of many options.

6.EDGES AND DETAILS
It can be pressuring at times when having to work on small details but we're gonna tell you to have fun with it. Think of it as the moment you put your brilliant judgment to work.
The best thing about details is that you can assign a different time to work on it — and that's when you're coming to the end of the drawing.

SCAN THE QR CODE
FOR MORE INTERESTING MUSIC

Step 1: Take out your color pencil/water color
Step 2: Put on your headphone and scan the QR code below

Step 3: Make a cup of coffee!
Step 4: Enjoy your beautiful time with this coloring book!

If you've ever released stress by dancing around your room to your favorite tunes or enjoyed a good cry with the help of a touching love song, you know how t music can be. It can lift you when you're low and calm you down when you're anxious.

Music is a powerful tool for mood regulation and stress. The best part is it's always available to anyone who needs it.

• •

Whether you're on edge or need a boost, just one song can bring you back to a more even and healthy place. When it comes to your mental health, music can:

HELP YOU REST BETTER:

A study involving students found that listening to relaxing classical music at bed-time improved sleep quality. This activity was also associated with decreased signs of depression.

LIFT YOUR MOOD:

Research shows that listening to happier music can make you feel more comfort-able, especially if you try to lift your mood while listening. There's also evidence that formal music therapy can help with depression when used alongside other treatments.

REDUCE STRESS:

If you're feeling anxious or stressed, calming music can help to settle your mind. Several studies have shown that when people undergoing surgery hear calming music, they have lower blood pressure and need less pain medication than those who don't listen to soothing music.

FOLLOW THIS INSTRUCTION TO GET REWARD:

1. Post your finished coloring pages on your Instagram
2. Follow us on Instagram @lainiedao
3. Send your finished picture to this email: lainiedao@gmail.com
4. Monthly reward for the most-liked person on Instagram

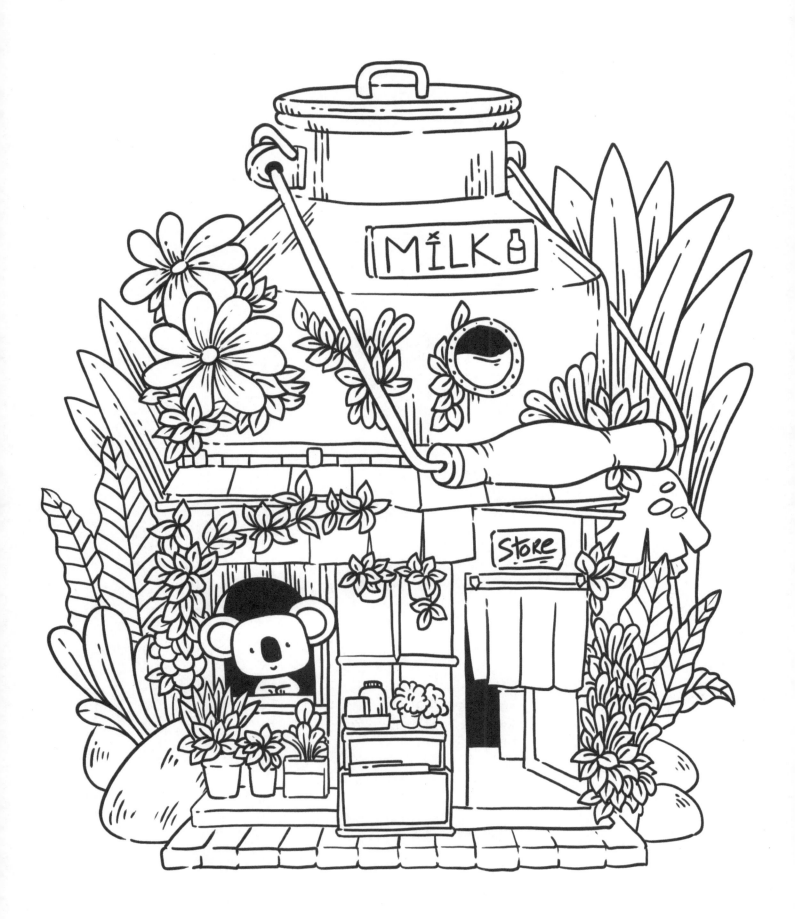

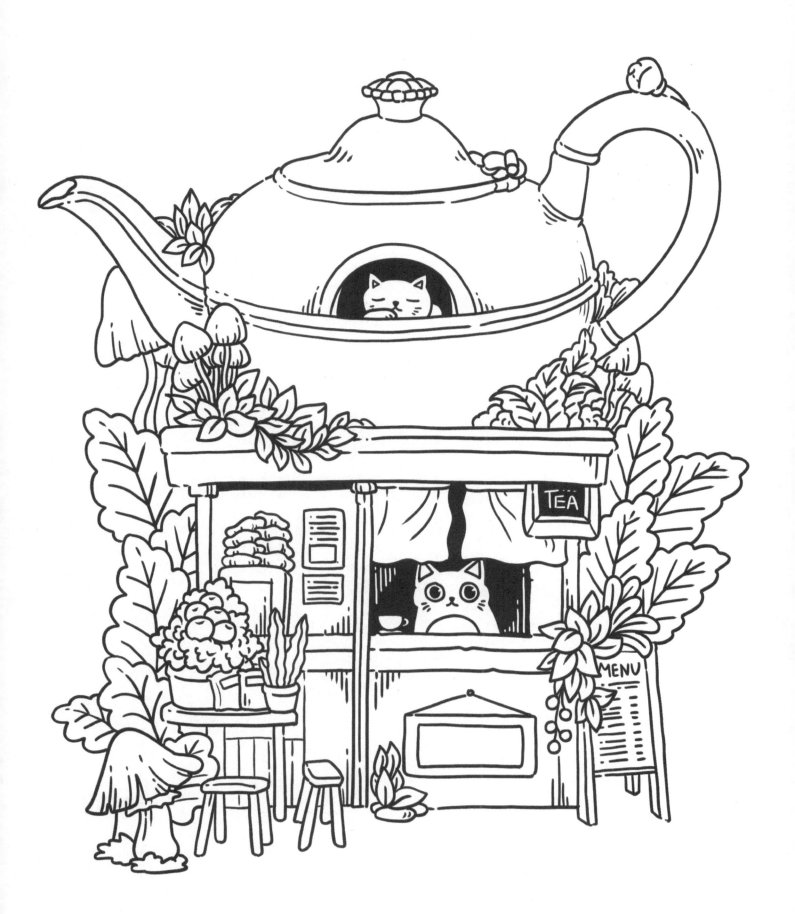

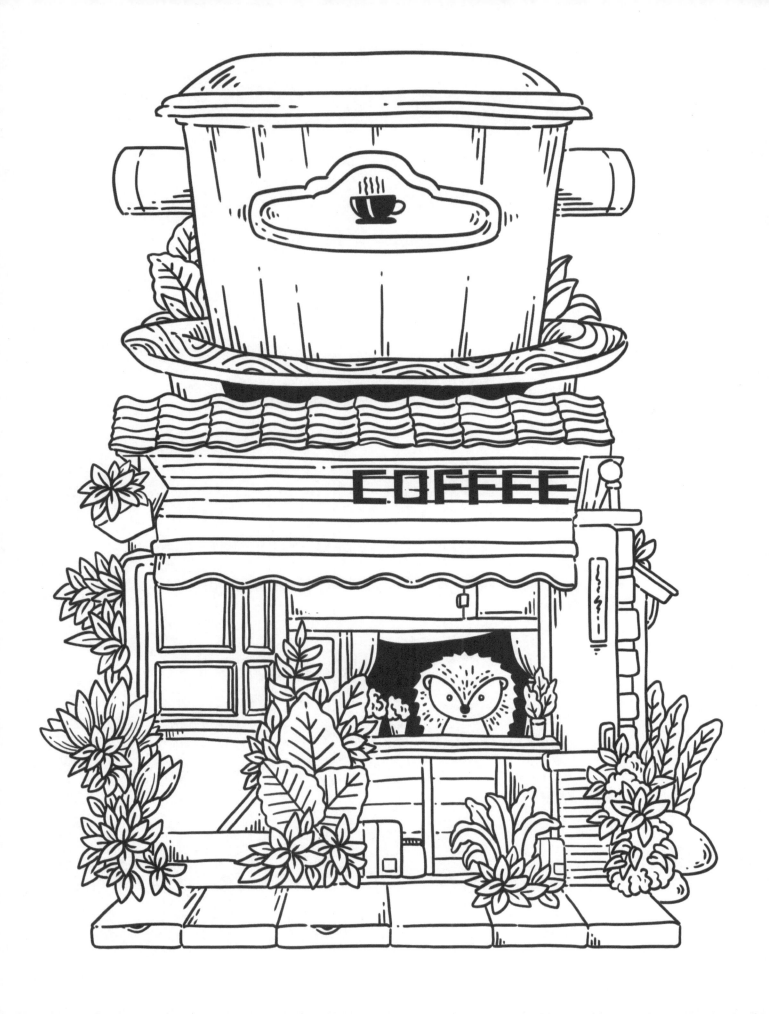

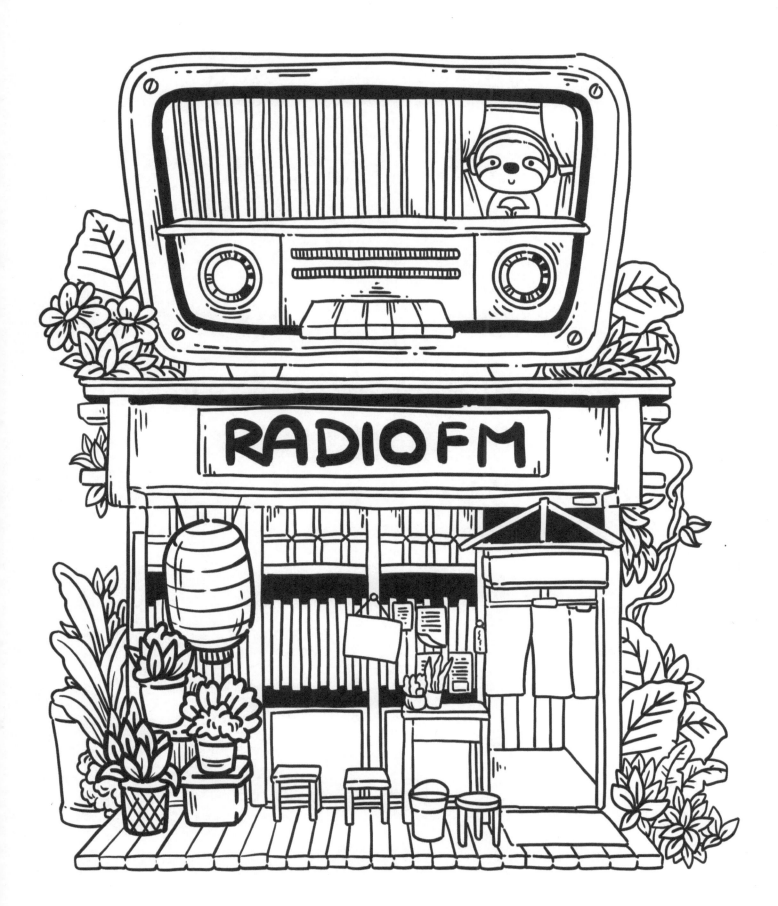

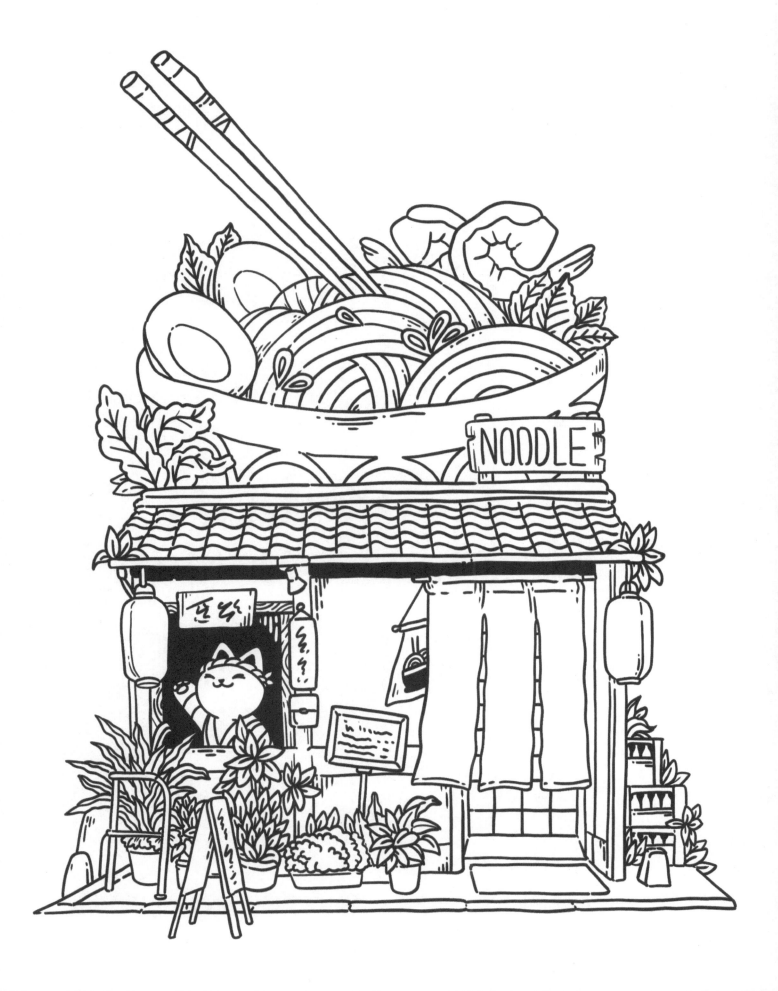

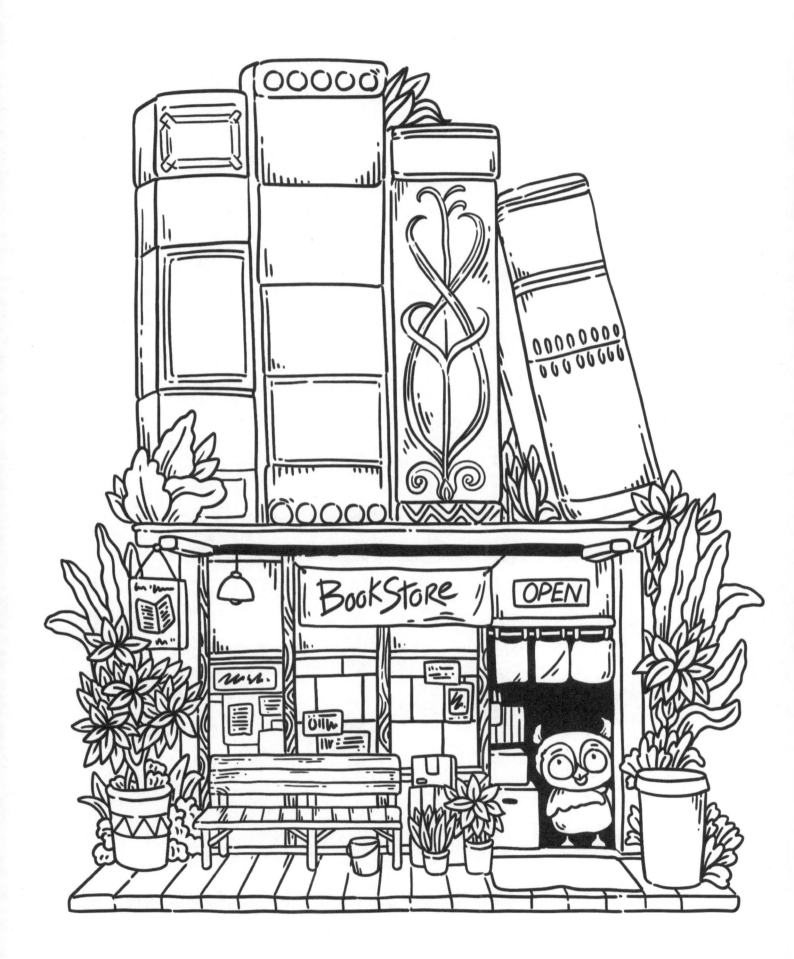

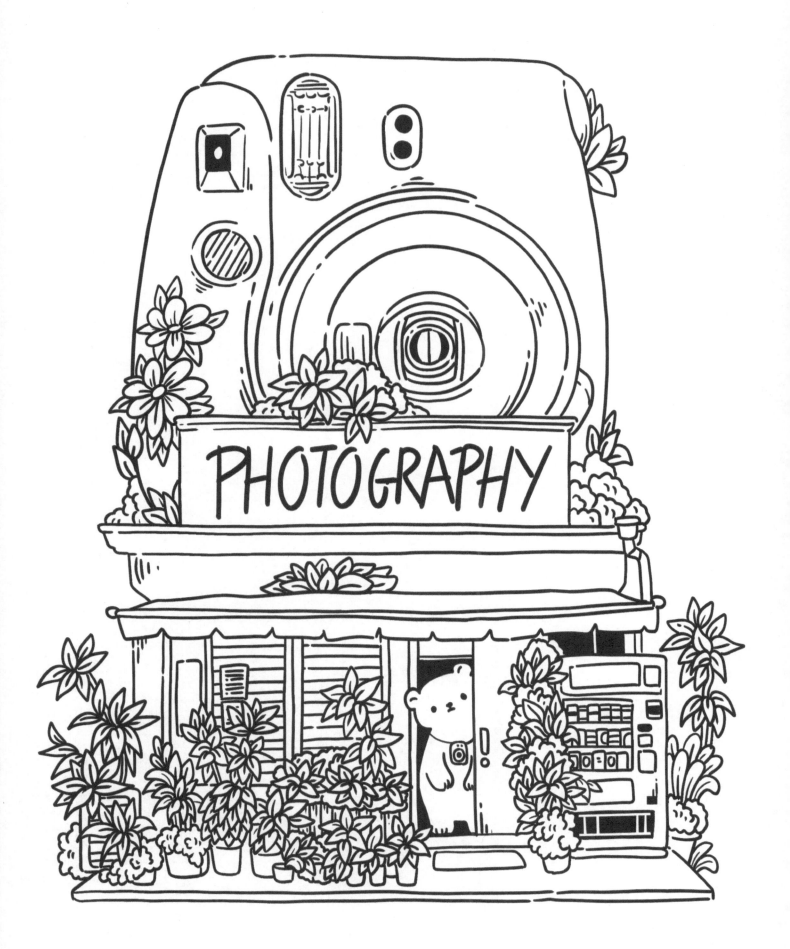

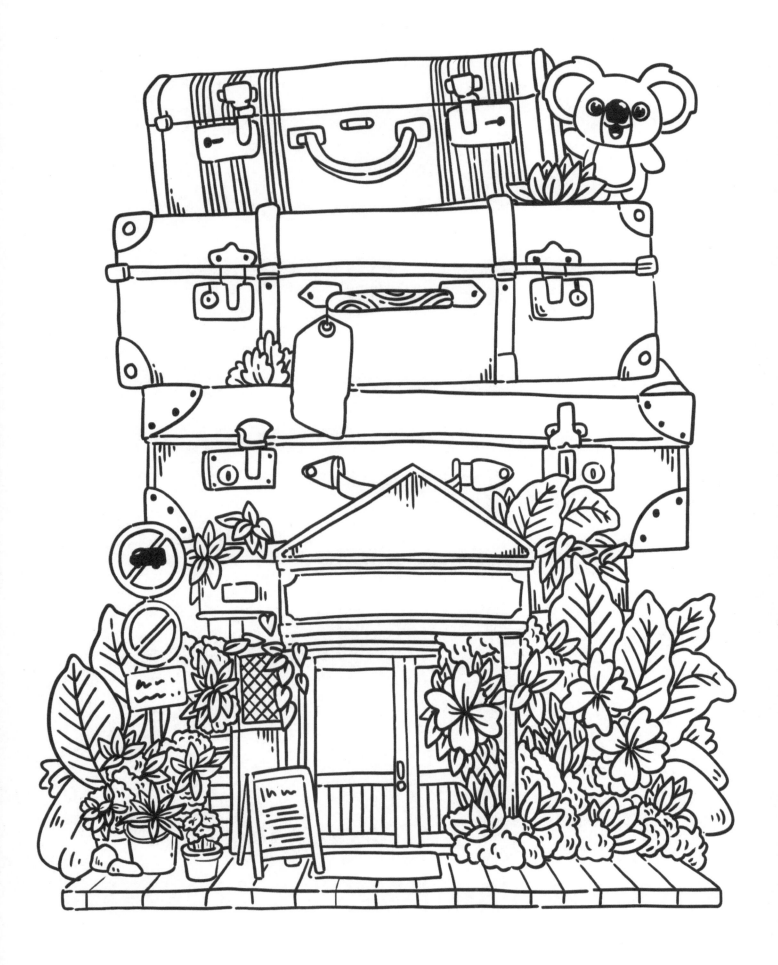

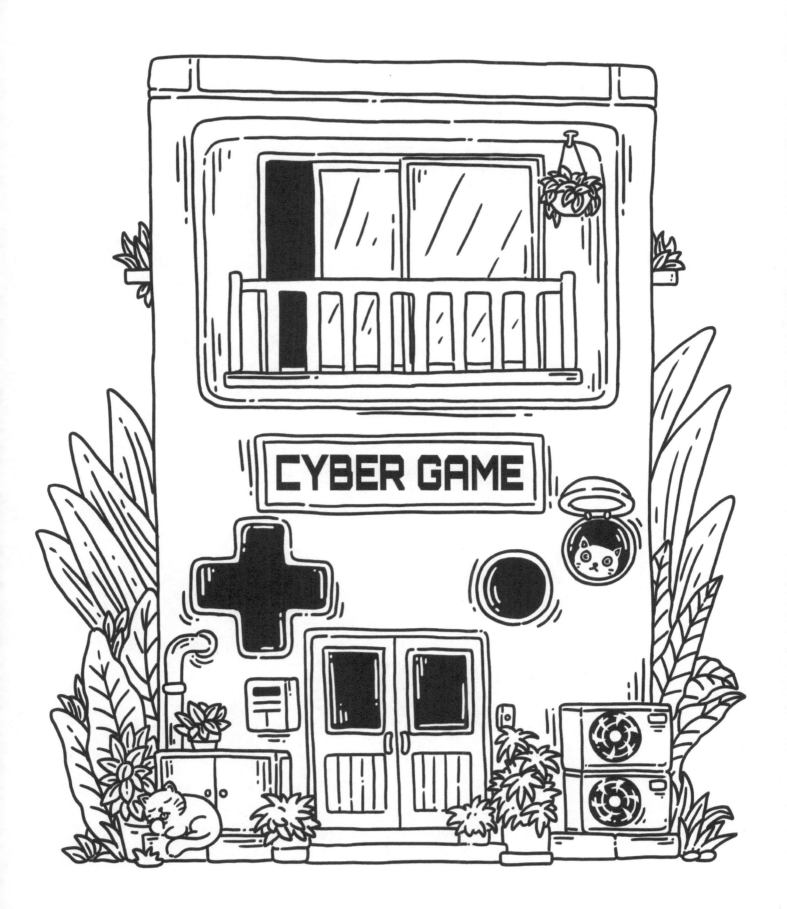

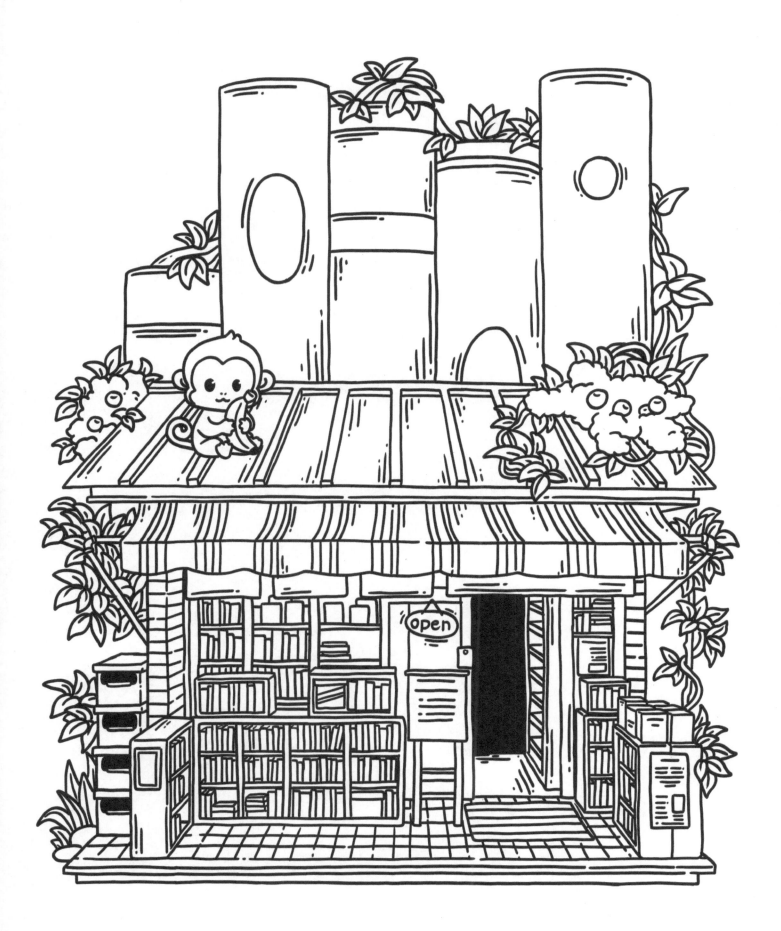

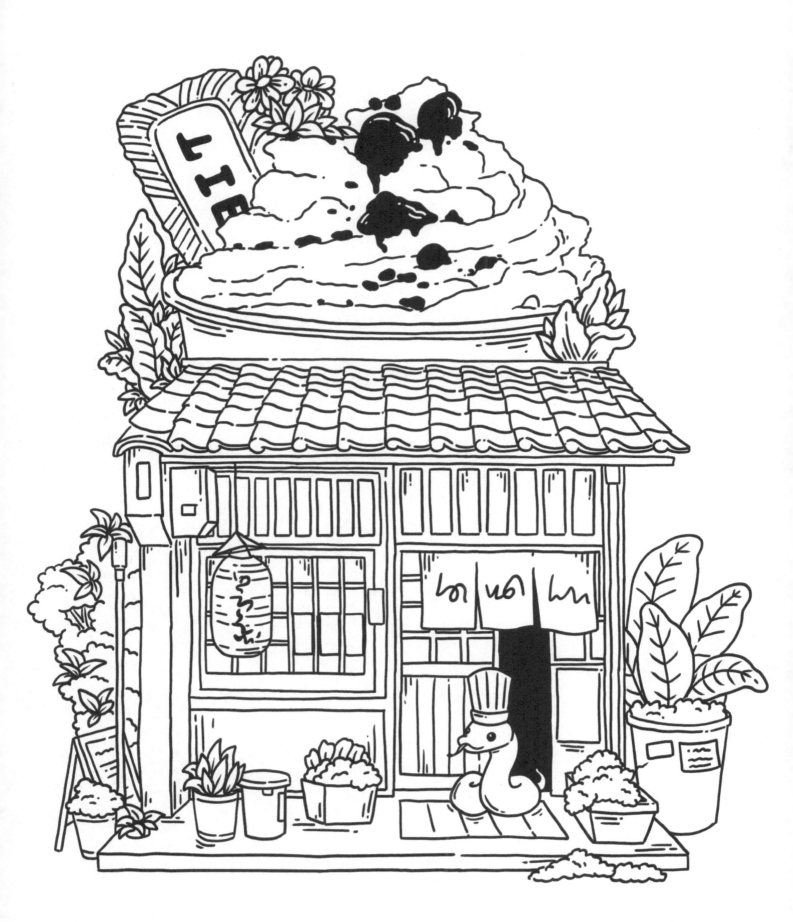

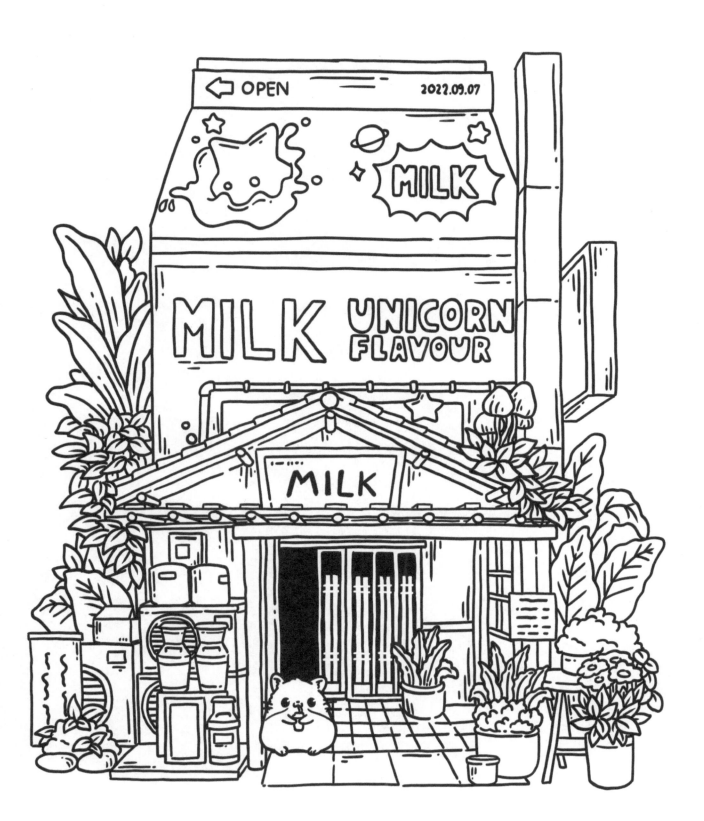

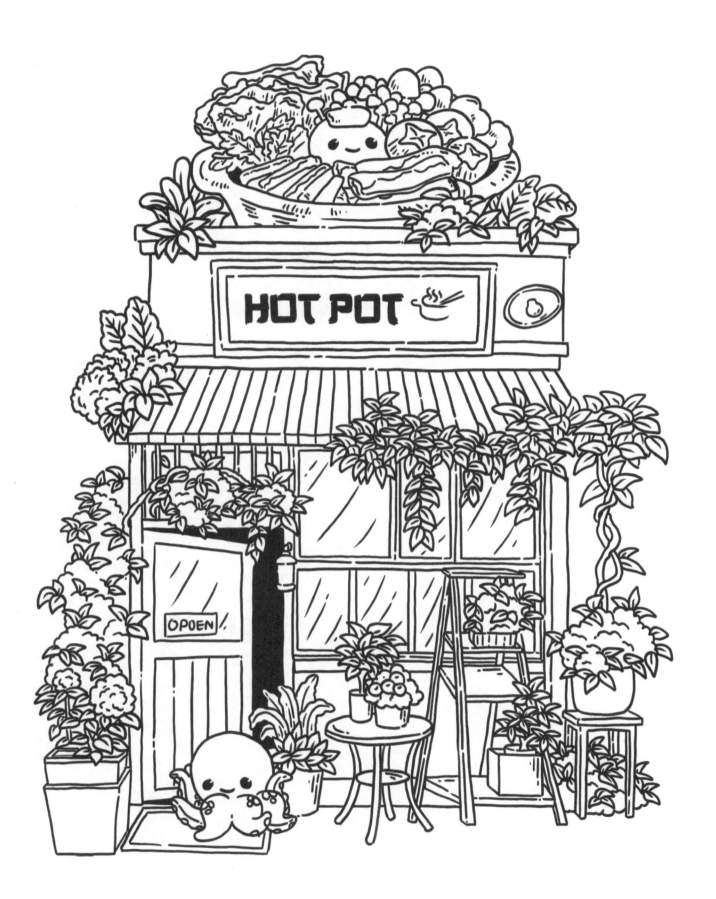

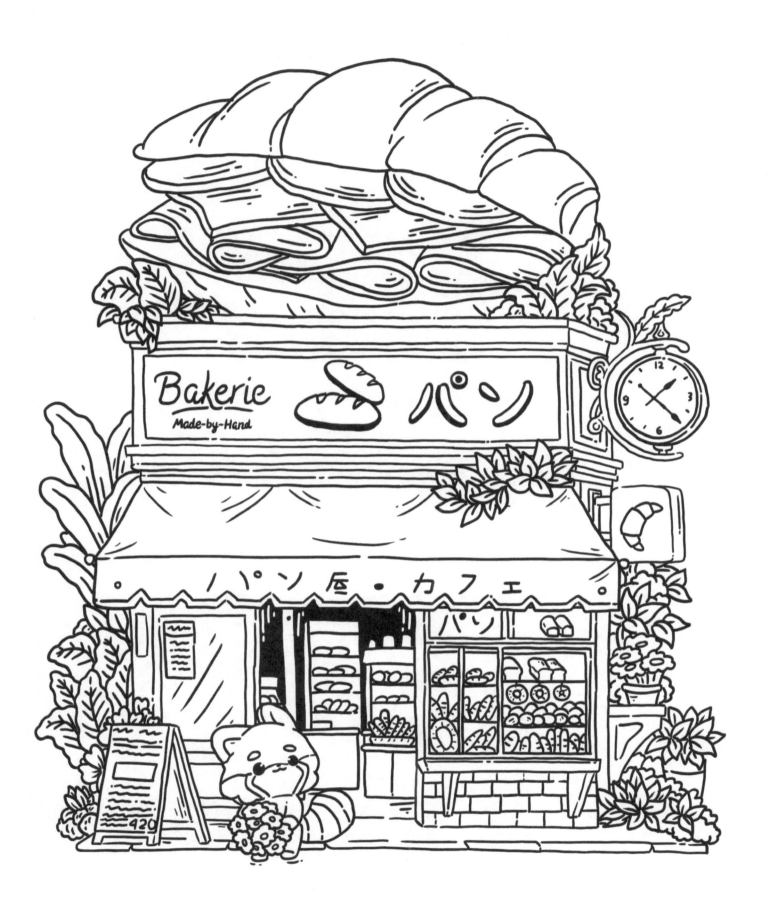

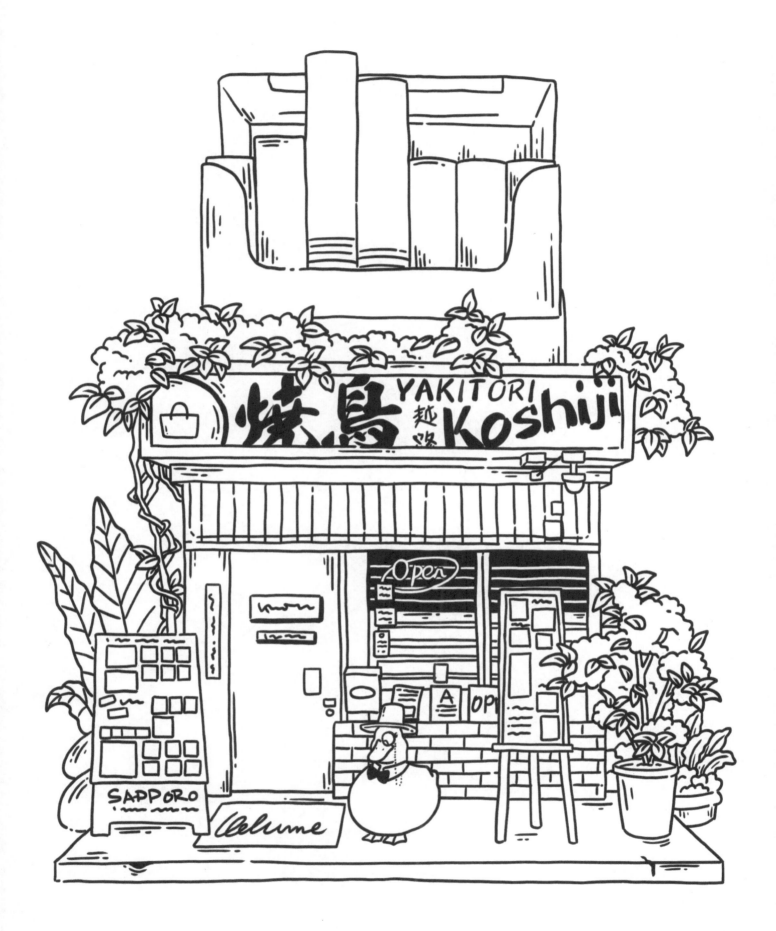

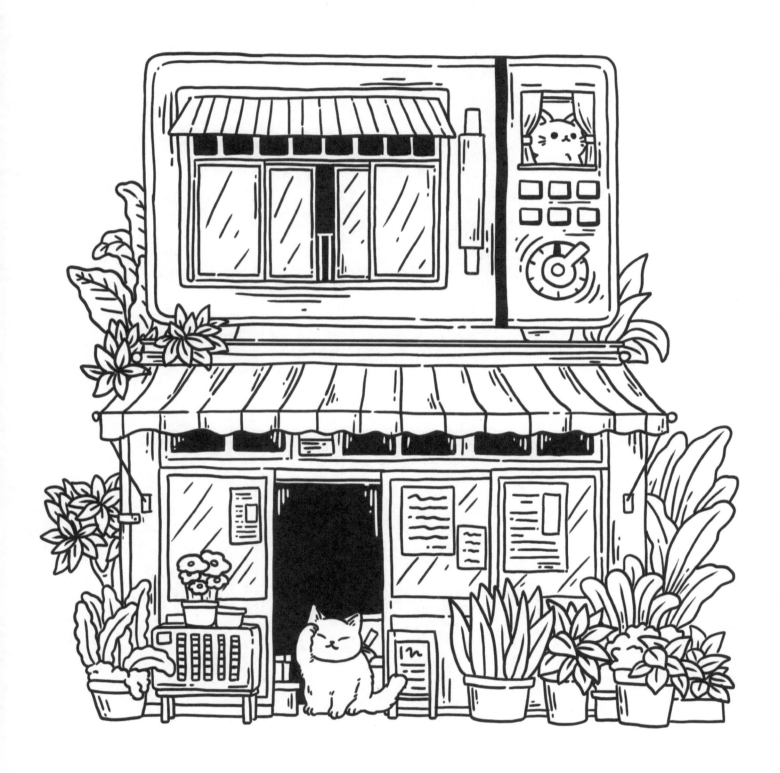

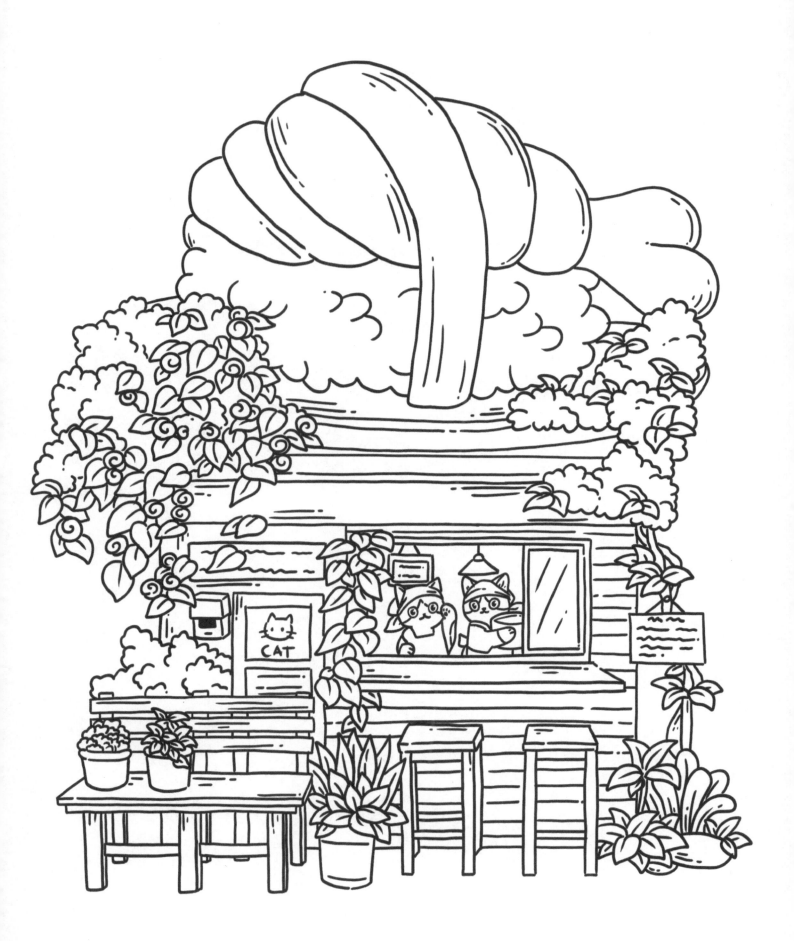

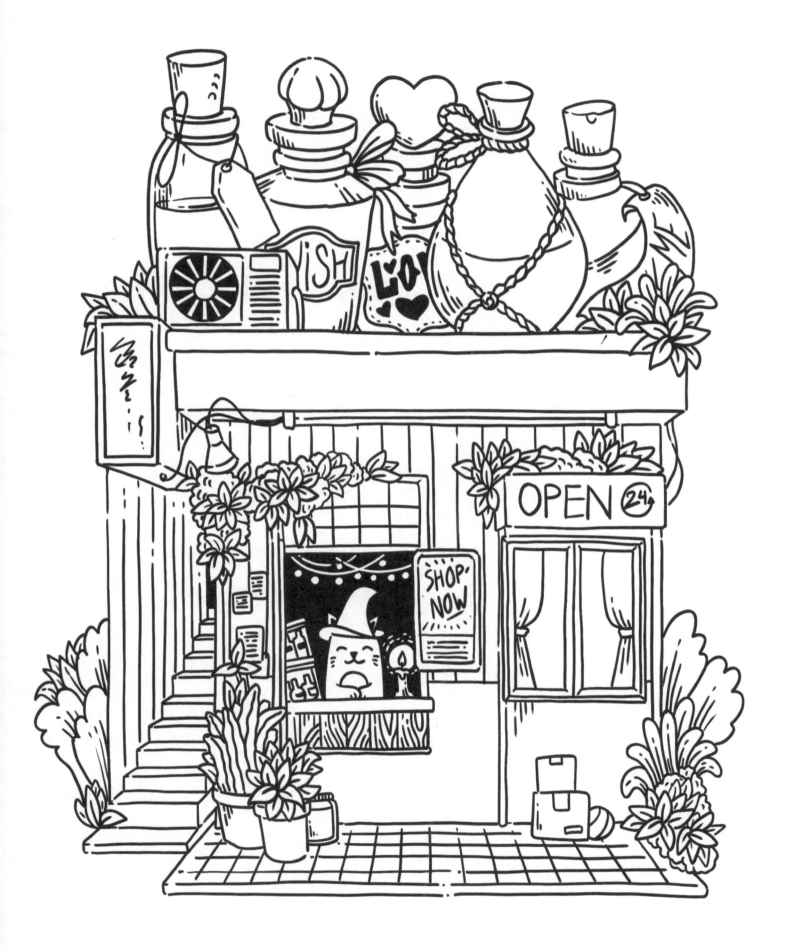

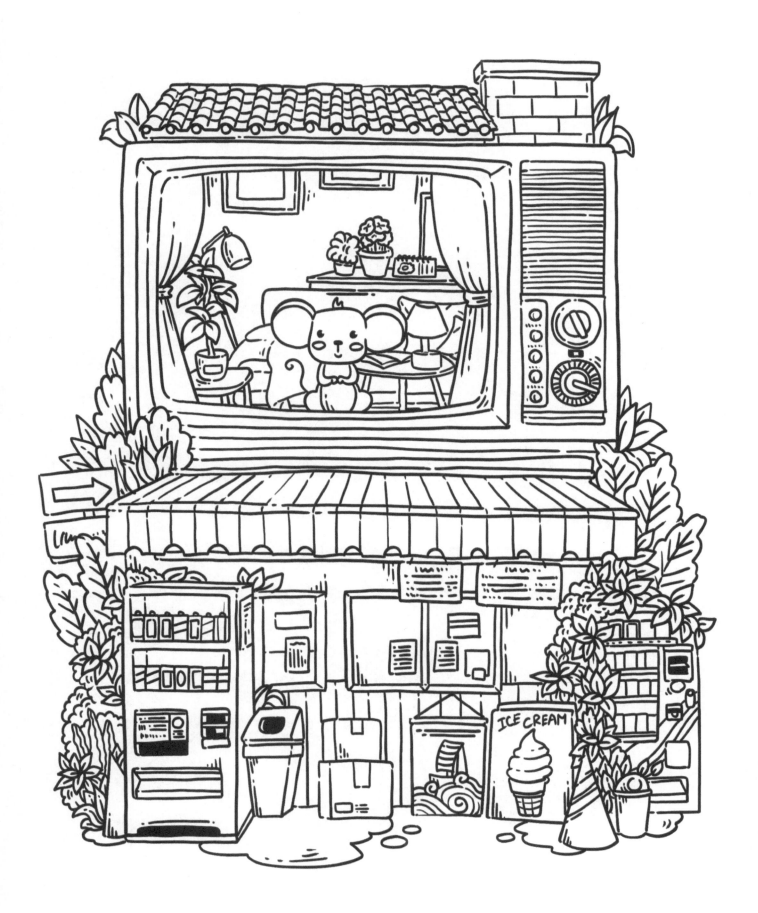

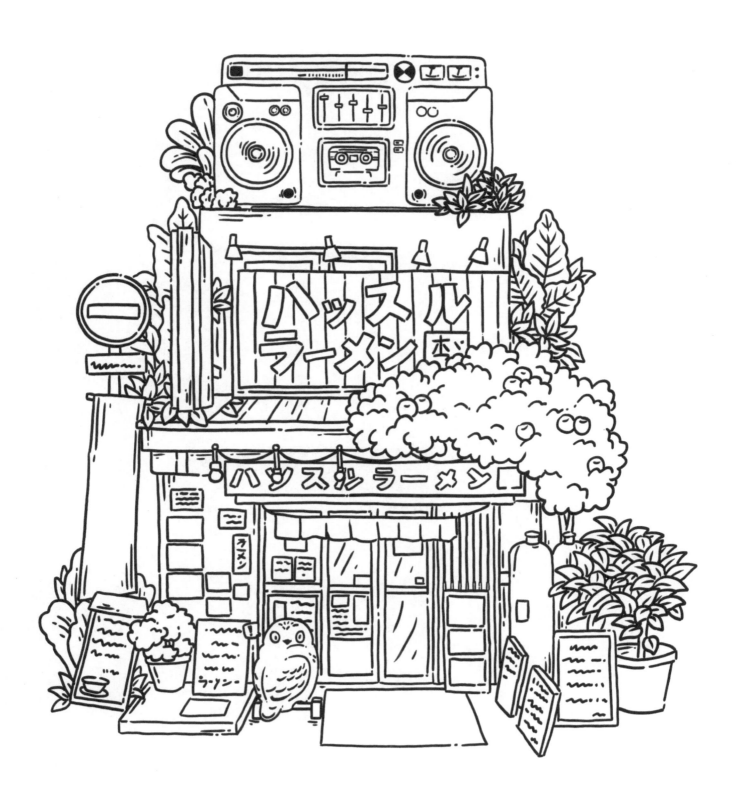

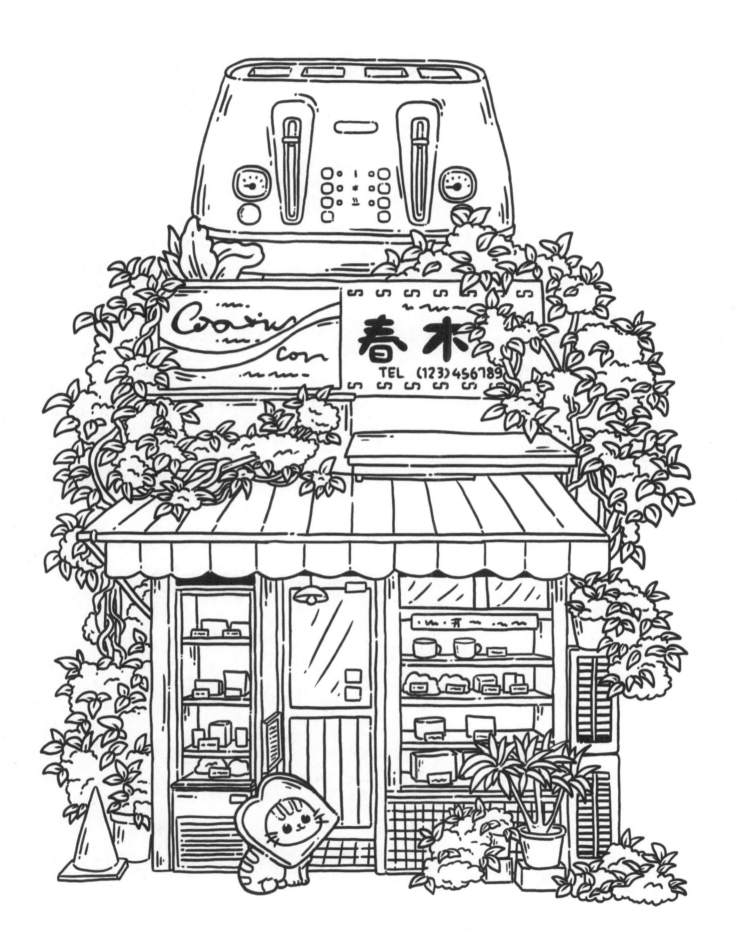

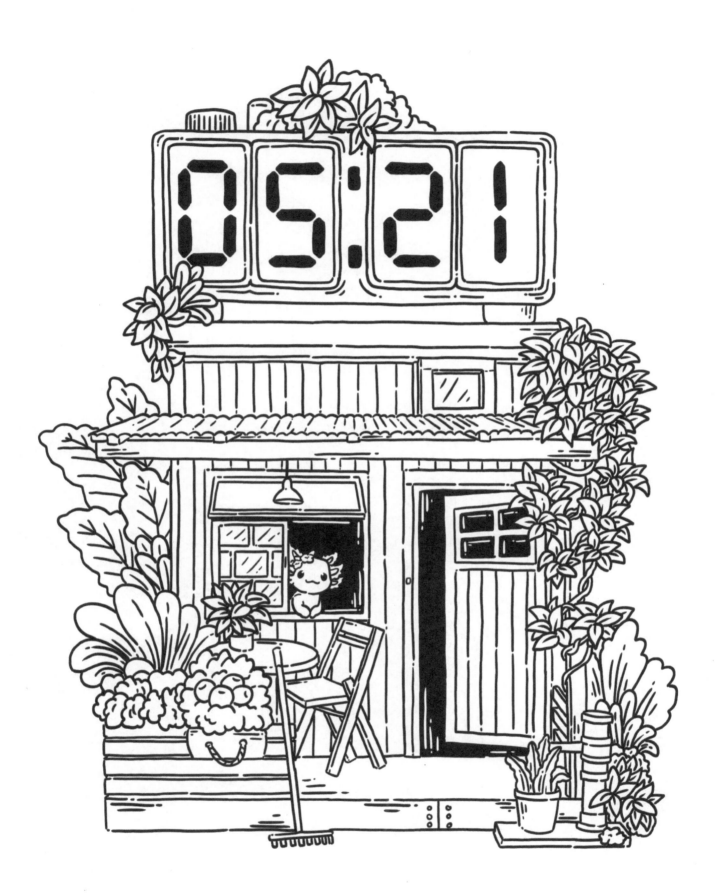

MENU

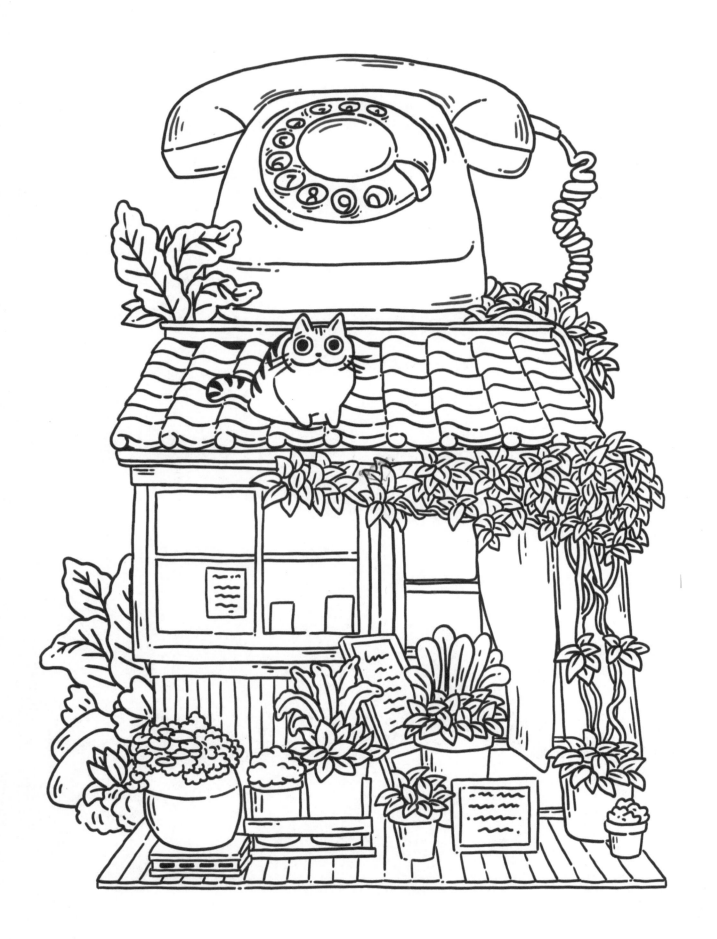

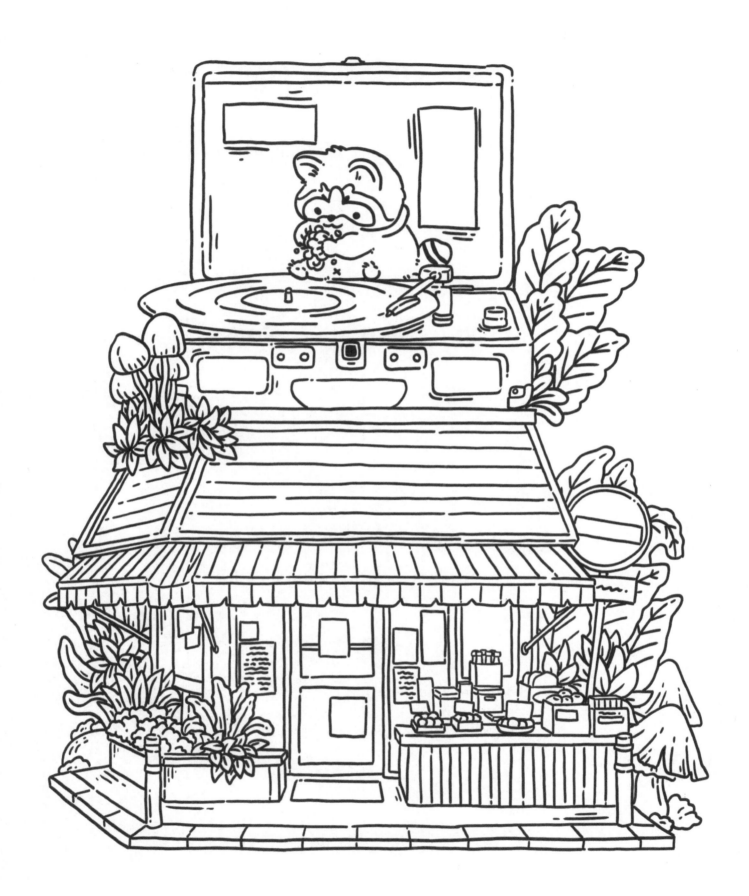

Made in United States
Troutdale, OR
12/11/2024

26264740R00038